DOKRA
A DYING ART?

SOMNATH BISWAS & RASHEEK AHAMMED

Copyright © Somnath Biswas & Rasheek Ahammed
All Rights Reserved.

ISBN 978-1-63974-738-2

This book has been published with all efforts taken to make the material error-free after the consent of the author. However, the author and the publisher do not assume and hereby disclaim any liability to any party for any loss, damage, or disruption caused by errors or omissions, whether such errors or omissions result from negligence, accident, or any other cause.

While every effort has been made to avoid any mistake or omission, this publication is being sold on the condition and understanding that neither the author nor the publishers or printers would be liable in any manner to any person by reason of any mistake or omission in this publication or for any action taken or omitted to be taken or advice rendered or accepted on the basis of this work. For any defect in printing or binding the publishers will be liable only to replace the defective copy by another copy of this work then available.

Contents

Preface *v*

1. Introduction 1
2. History Of Metal Casting 4
3. Dokra; Pioneer Of Indian Traditional Art 7
4. History Of The Ancient Sculpture Art In The Indian Subcontinent 11
5. Famous Places Of Dokra In India 13
6. Hollow Casting 15
7. Solid Casting 23
8. The Age Of Uncertinty 27
9. Dokra; A Mark Of Art Education 30
10. Through The Eyes Of The Students 34
11. Album 40

Preface

To be a good citizen, you need a good education & culture. It is very important to be a good citizen in today's society, why am I saying this? Many well-known and unknown conversations come to the ears, but I think it is possible to become a good citizen by gaining knowledge with a good education & culture. Working in Jawahar Navodaya Vidyalaya for the last 26 years, I have seen, realized, spread knowledge and achieved different cultures in different places in my career. I have participated in many local and foreign events, workshops, seminars, exhibitions, I have received honors from the Navodaya Vidyalaya

Samiti, but somewhere I felt that my words should be kept somewhere as a book, to share my thoughts. Let's go. If there is cooperation of students like 'Rasheek Ahammed' then many teachers can do a lot. The only focal point of so much talk is 'Dokra Art'.

There is nothing new about Dhokra Art, everyone can find out by Google. However, I feel that it will help the readers to get new supplies, everyone will like it, that conducting such a difficult education or workshop like 'Dokra' in a residential school like Navodaya is really a challenge, and it has been possible only with the cooperation of students.

I started Dokra workshops in Jawahar Navodaya Vidyalaya, West Midnapore in 2009, and have not stopped since. But the question is, why 'Dokra Art' all of a sudden? And it could have been something else. As an artist, I understand that there is a lot of work to be done in this industry. And knowing that there is no guarantee of this art, many artists have been working day and night keeping this art alive.

This 'traditional dokra' art seems to be lost somewhere. We should all work together to keep this art alive, stand by the Dokra artists, and cooperate in spreading some of its propaganda.

Jawahar Navodaya Vidyalaya: (JNV) is a system of central schools for talented students predominantly from rural areas in India. They are run by Navodaya Vidyalaya Samiti, New Delhi, an autonomous organization under the Department of School Education and Literacy, Ministry of Education (MoE), Government of India.

PREFACE

Somnath Biswas: Art Teacher: JNV Murshidabad

Navodaya; truly a launching pad. Perfect place for a student to nourish and develop his/her potential of creativity. It is one of the very few schools, which provides such a wonderful platform for the students to develop their creative skills along with the best quality of education.

In my early school days, as a child I always wanted something new, something creative, but due to lack of

resources and confidence I never took it seriously. But when I stepped in JNV, I got a magnificent platform and got a good opportunity to develop my creativity.

I am not good at painting but I love craft works. Till class 8 my art teachers Smt. Susmita Paul and later Shree Shyama Prasad Pal sir helped me everywhere I needed. He was a wonderful person and a very good teacher. After his retirement a new teacher Shree Somnath Biswas joined our school. I met him before in a scout camp at JNV Nadia. From the first day he made me his assistant in the activities. Biswas sir is a completely different teacher, one of his kind, very inspirational and energetic person .Within a few months of his joining; we have done a lot of work in our school. We decorated our academic premises, created many wall paintings, made different sculptures and organised many such other programmes. I am not good at painting but still sir has motivated me to participate in the wall paintings. That was really a great experience. We have organised an International Art festival in our town where many foreigners participated. Beside our academic activities we always use to do many new and creative arts and craft activities in school.

Now it's a very big pleasure for me that sir has given me this opportunity to assist him as co author for this book. I hope it will be a great journey for both of us and I hope we will do a lot of work like this in future.

PREFACE

Rasheek Ahammed: Student: JNV Murshidabad

ONE
Introduction

The main goal of an ideal student is to acquire knowledge. Education is the identity of man, the armour of the educated. From birth, human learning begins and continues until death. Textbooks are of utmost importance to young students. But extra-curricular education is also essential for a better future. Along with studies, sports and other creative activities are very important. Prolonged reading of any textbook creates a monotonous feeling. The ideal way to overcome this monotony is to concentrate on another activity for a while. Nowadays with the wealth of smart phones we have no way to get leisure time. With the help of mobile we can know the news from all over the world, but for the students the importance of external news is minimal. So it is more profitable to do some creative work in leisure time and without going to social media to get rid of boredom. On the one hand such monotony is removed; on the other hand its use in leisure time is also completed. Simultaneously, independent thinking is developed.

Not only for utilizing leisure time or to overcome anxiety; the historical significance of creative work like Dokra is immeasurable. How a traditional art that is

thousands of years old still survives today is truly an unimaginable thing. If you think about it for two minutes, you will be amazed at how hard work like Dokra survives in this age of busyness and modernity. This impossibility has been made possible only by a handful of Dokra artists, who are working tirelessly every day not only for a living but also to keep this traditional art alive with affection.

Plastic is currently the greatest enemy of mankind. Almost everything we use in our daily lives is made of plastic. Most of the plastic is non recyclable. As a result, the amount of plastic pollution is increasing day by day. Once it is made, it is almost impossible to destroy the plastic. So we need to reduce the use of plastic as much as possible to protect the environment. Dokra artifacts are a very good option to replace plastic toys and showpieces. This will reduce the use of plastics on the one hand and help promote the industry on the other. Dokra objects are as durable as they are beautiful.

No doubt, melting and moulding was the Primary step for the primitive people towards civilization. It's almost impossible to tell the exact time, when and where the metal work began but historians have found many traces all over the world and estimated that it was 4000 BC when the primary metal works started. Several traces of these metal works have been found in Iran, Syria and Palestine and Thailand.

The early men might have noticed how the molten metal from the volcanoes cools down and takes a rigid shape. From these observations they might have tried to melt the metallic rocks and succeeded. The next work is to shape the metal with moulds. Most likely they used clay for making moulds as we find several traces of clay works before the metal era. It took hundreds of years to learn the use of wax

in moulding. The desired model was made by wax along with the fine details and then covered with clay, burned to harden it, drained out the wax by melting and got a wonderful mould. Just pour the molten metal in the mould and you will get the exact shape as you made with the wax. In the early period we find artefacts made with copper, later we see the use of bronze and tin and gold also.

One very popular device was found in Mesopotamian civilization, a cylinder on which various minute designs were carved; probably this was used as a seal. They might just be used to roll on moist clay and dry it. This device could be used for several purposes, such as early press or as a seal for making agreements.

Gradually the metal work processes have spread all over Asia. We have found a few gold pins; probably used in dresses and many bronze vessels made by the lost wax technique all over West Asia. Even more artifacts were found at the caves of Nahal Mishmar close to the shore of Dead sea.

In the Mesopotamia civilization, the land between the rivers Tigris and Euphrates, the lost wax technique was developed most efficiently. Though this place was abundant of copper ore but several pieces of evidence of trades are there. So we can conclude the Mesopotamian people imported copper from distant places. Many jewellery items and deities of different gods made of pure copper in the temple were found in this area.

The sole purpose of this book, an ancient art like Dokra, is dying today. So this is our little effort to spread the word about this art with due respect to the great artist of this beautiful art.

TWO
History of Metal Casting

Anatolia and Greece

In Anatolia, Historians have found a number of copper casting bulls and stags. The whole body of these artifacts were made of copper but the horn and other minute details were gilded with gold. This proves that, How improved they were in metal casting.

Trade was a great way for art and culture to spread over distant places. The traders from the Mesopotamian civilization carried away the art of lost wax technique overseas and even to the mainland of Greece. We have found a number of ornamental pieces, human figures and many other artefacts from the areas of Greece.

It is clear that Mesopotamian civilization used a type of contract, in which they used a cylinder with minute figures inscribed in it and rolled over a moist clay pad. Historians have found similar clay pads in the lands of Greece; this implies that the Mesopotamian civilization was greatly

connected with the areas of Greece

Now it is clear that lost wax technique became more prevalent in the areas of Greece, Crete and Cyprus as we have found many examples of human and animal figures, chariots. The technique travelled further in the North reaching Denmark and Southern Sweden. In this region the art got a great prosperity. The well known 'Sun Chariot' which was made in the 14^{th} century BC was found in this area. The Chariot comprises a big gold disk on which, there is a four wheel chariot along with bronze horses which was hollow casted over a clay core.

Egypt

Egyptians were predominantly masters of metal works. They used to hammer gold nuggets into sheets and later made ornaments and utensils from them. It took a little longer for them to accept the lost wax technique but when they started to produce different artifacts with this technique the technique got a new height. The Egyptian craftsmen combined their style with the lost wax technique and used it to make beautiful ornaments and deities of different Gods.

Types of metal casting in history

In the early time solid casting was the most common method, but when we are working on gold, solid casting becomes very expensive. So another method of metal casting evolved which is hollow casting. In this method a rough clay core was made and then wax covering was done

as much as the desired thickness of the original model. Then another layer of clay was added and baked. The wax was drained out and molten metal was poured in the mould. Though, this method of casting was introduced for the expensive metal casting like gold but eventually this method became the most practiced method and with other metals also.

The solid casting and hollow casting together were known as direct casting. Another method of casting evolved soon. It was named as indirect casting. In this method, permanent moulds of different fragments of a model were made and moulded separately, later they were combined together. This method was used for commercial purposes as there was a use of permanent mould, they could use this again and again and each model prepared will be exactly the same.

In different parts of the world, artisans and craftsmen mixed the lost wax technique with their own style and thus several new designs evolved but all of them had the same origin.

THREE
DOKRA; PIONEER OF INDIAN TRADITIONAL ART

Dokra or often Dhokrais a form of sculpture art, with the base non-ferrous metals; specially copper based alloy used in ancient India for over thousands of years. One of the greatest examples is the iconic *'Dancing girl'* from ancient Indian civilization Mohenjo-Daro which was made in 2500 BCE and the 'Mother Goddess' of Adichanallur, Tamilnadu. According to the historians, Dokra or the lost-wax metal casting was well known to the native Indians for over 4,000 years. In the ancient time people used to make jewellery and ornaments from copper and similar alloy using this technique. Beside the ornamental purpose, this technique was also well used for making decoration items. Ancient dokra horses, peacocks, owls are a good example of that. Religious statues and images using the lost wax casting

were also found.

In the history of South India, during the rule of Chola dynasty, the lost wax technique was greatly boosted. In this period this art reached the highest peak of excellence. The bronze sculptures of Hindu deities of this time became very famous later. Nataraj figures of the Chola period are the most famous ones.

But in the current time somewhere this art lost its momentum due to some serious challenges.

- Poverty; most of the families or artisans related to this art belong to a very poor section of our society.
- Raw materials are getting expensive and ultimately the whole products become expensive but the consumer wants cheaper goods and thus the demand for these products in the local markets is reducing day by day.
- This art needs hard labour and comparison of this, profit is less
- Time consuming; a simple product takes 15-30 days to make
- The new generation is not interested on such art, thus no new artists are taking this profession
- Many other new and easy methods of metal works are emerging
- High competition with factory made items
- Producers are small thus cannot reach distant consumers
- The artists stick to their primitive methods and are not ready to use modern tools and methods.

Undoubtedly Dokra has its own unique identity but why should we know Dokra over many other arts?

The reasons are –

- It is the authentic Indian handicraft influenced by our tradition and culture
- It is Eco-friendly, there is no carbon footprints behind
- Buying Dokra artifacts will benefit the local artisans and in the long run; it will benefit our environment.
- One mould is used once only, so each and every model of dokra is unique.

To support and save this excellent art form we must take some initiatives:

- Government can take several initiatives to promote this art
- Non-government agencies can be created who will provide insurance to these artisans
- Protection need to given to this art
- Research should be done to improve the techniques involved in this art
- Combination of working style and art form should be done to create new styles and techniques

In recent times different state governments, many non-profit organizations and individuals came forward to promote dokra nationally and internationally. Dokra products like animal figures, designed boxes, bowls and lamps have high demand in the international markets for their simple but attractive designs and folk art forms.

Many digital platforms like 'Peepul Tree' are working closely with the local artisans all over the India providing them facilities to reach their products in the national and international market

Few years ago in West Bengal, National Institute of Science Technology and Development Studies (NISTADS)

launched a project in Bengal Engineering College to develop a fuel efficient and permanent furnace for Dokra artists. In the year 2000, a community furnace was established in Bankura which provided improved tools and technology for the artisans. The result was amazing; it boosted the production for those artists who used to work hours in the primitive open fire places.

FOUR
HISTORY OF THE ANCIENT SCULPTURE ART IN THE INDIAN SUBCONTINENT

It is believed that a branch of people from the Mesopotamian civilization settled in the Indian subcontinent, they brought this magnificent art with them.

This magnificent art took its name from the 'Dhokra damar' tribes of West Bengal, who were distant relatives of the Gond and Ghadwas of central India. Their traditional technique of lost wax casting is now known as the Dokra metal casting.

The original Dhokra damar tribes were found in Central India. The community from Jharkhand later extended and one branch settled in West Bengal, others travelled through Odisha. Another cousin branch of Dokra, in Chhattisgarh

extended and travelled towards west and south west, settled in Rajasthan and Kerala and now found all over India.

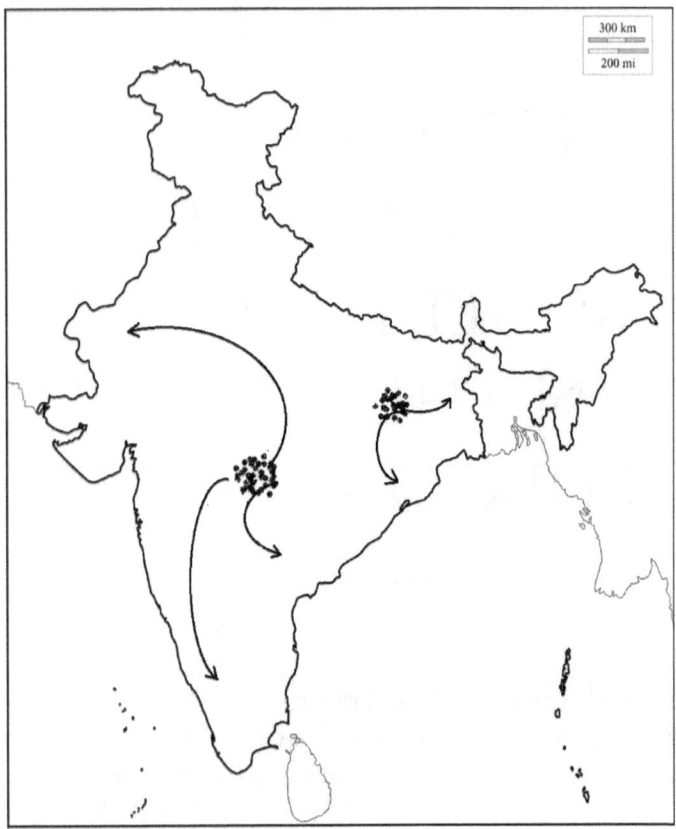

FIVE
FAMOUS PLACES OF DOKRA IN INDIA

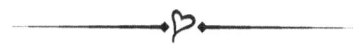

The mineral rich areas such as Jharkhand, West Bengal, Odisha, Chhattisgarh, Madhya Pradesh & Telangana are widely known as Dokra belt as it is the home of original inheritance of Dhokra Damar tribe one of the oldest tribes of India like- Gonds and Bhils.

In the recent ages Dwariapur of West Bengal got the fame for the production of extraordinary Dokra artifacts.

In Bikna of Bankura district there are more than 150 families of Dokra artisans and they are famous for their Bankura Horses

More than 130 odd artisans of more than 45 families are there at Sadeibareni in Dhenkanal district of Odisha

Bastar Dokra Art of Chhattisgarh is famous worldwide for their excellent casting, specially the dokra bulls

Kandhamal in Odisha is famous for the deities of Lord Jagannath

DOKRA

Pundi village in Jharkhand is the home of Malhore or Malhar tribes who are famous for their brass containers with detailed animal and bird motif.

Tatari Ranas and Tatari Naiks of Mayurbhanj in Odisha are famous for their unique style and forms.

50 families of artisans are there at Keslapur of Asifabad-Komara Bheem district

Ektal in Chhattisgarh have their own style and form.

In south India Swamimalai, Tamilnadu, Mannar, Kerala are famous for utensils, bells and lamps.

Recently in 2018 Adilabad Dokra from Telangana got the Geographical Indication tag.

Not only in India, the lost wax technique is practiced in different countries all over the world, such as in China, Egypt, Malaysia, Nigeria, Central America and other places.

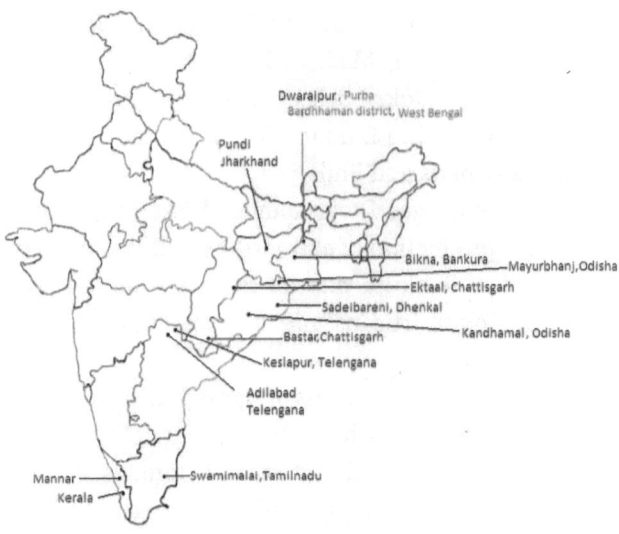

SIX
Hollow Casting

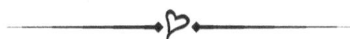

Materials required: Pure raw bee-wax, Big aluminium bowl, Mustard oil, Black soil, Wet clay, Pitch (a thick black substance obtained from tar), Pure dhuna (resin), Charcoal fire pot, Big plastic/aluminium pot, Sand dust, Cow dung, Coal for fire/furnace, Iron tools (file, batali, iron brush etc)iron ware, scrap bell metal pieces

<u>Step i)</u>Make a model of coarse clay of any design then dry it in the sun or by mildly firing it in an oven (taking precaution) next make the model in definite shape determine its size without the small details like eye. Make the head of the model separately with wet clay

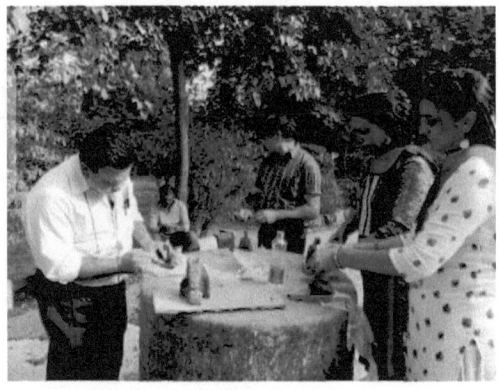

Step ii) How to prepare 3 mixtures a) Mixture of wax b) Mixture of pitch and dhuna (resin) c) Mixture of wax and mustard oil

We have to take dhuna (that is the resinous gum of Sal tree) without water quantity. (For example) 1kg, add 600g of Bee-wax with dhuna (resin) in the vessel until they get properly mixed. Then; we have to add 50g of mustard oil to get a sticky effect. Then we have to add 200g of pitch (tar). Now using a fine cloth, filter the mixture and pour this in water in a plastic/aluminium pot.

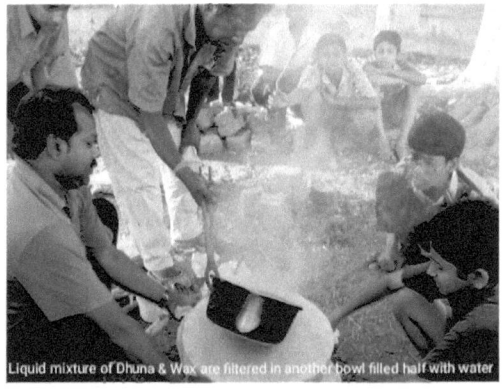
Liquid mixture of Dhuna & Wax are filtered in another bowl filled half with water

Step iii)Then we have to fire the dhuna (resin) in the aluminium/iron pot in the charcoal/wood fire. After a second filtration the mixture is immediately cooled with the help of water in a big pot, the cooled mixture is warmed again with charcoal fire and is stretched like thread. Without keeping any gap the threads are wrapped around the clay core to produce a replica that is smooth and expressive of art which is prepared by black soil. Then the legs, hands and other delicate parts of the body are made with Bee wax and affix them to the model.

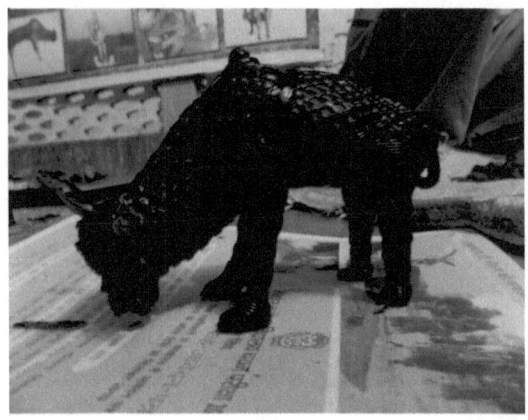

Step iv) Now the whole model is covered with clay, which is a mixture of fine soil and cow dung and let it dry.

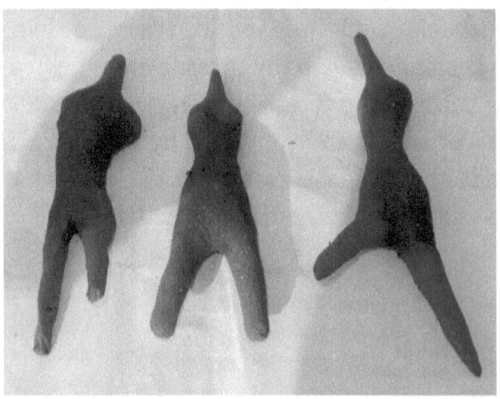

Step v) Now a mixture of black soil and water is made and applied on the dried model such that all the cracks are fully covered.

Step vi) Then we shall make a funnel with clay upward on the model linking with Bee-wax channel such that sufficient amounts of molten metal could be poured through it and let it dry in the sun.

Step vii) Now we have to make a big blast furnace with burning coal and put the well dried model in the flame. Also put the scrap metal pieces in the furnace inside an iron pot. First we will see red flame and after some time, when we will see green flames then we can understand that the metal is prepared for casting. Then with the help of a pair of aluminium tongs take out the model. The wax will be vaporized by the heat. Now keep it for a while to cool down.

*There is another method of casting. In this method we put the scrap metal pieces in the funnel, and place it in the furnace. By the heat of fire both the mould and metal burn together. Because of the heat the wax will be vaporised and the molten metal will occupy the empty space and take the shape of the model.

DOKRA

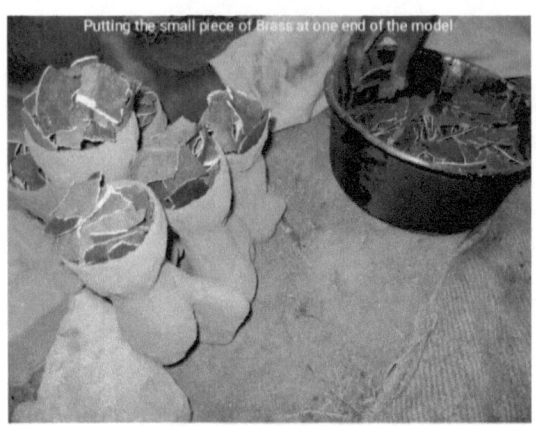

Step viii) Pour this molten metal in the hollow mould through the funnel carefully; shake a little bit very carefully so that the metal reaches every corner of the mould. And then plug the hole with clay.

Step ix) Now put the model in water. After cooling, break the layer of clay carefully with a small hammer and take out the original metallic model.

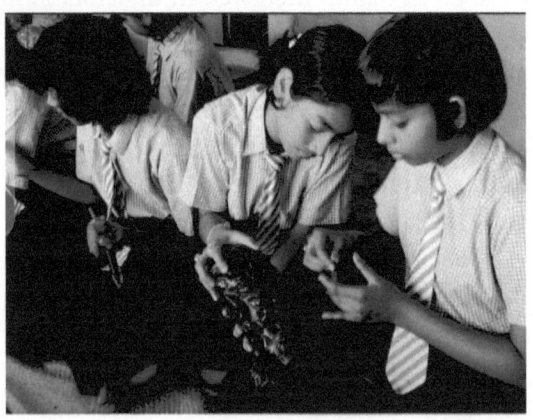

Step x) With the simple tools, do the final detailing.

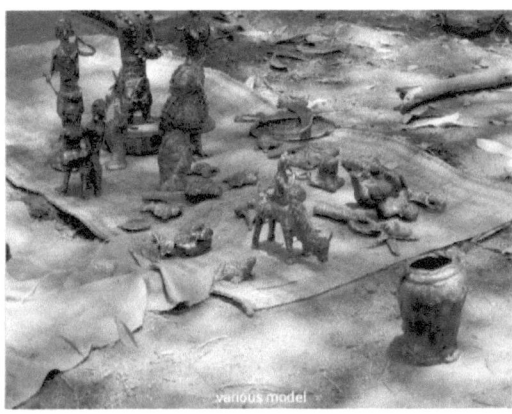

Step xi) Polish it as you want to give it desired finish and glaze. Now our bell metal model is ready.

DOKRA

SEVEN
SOLID CASTING

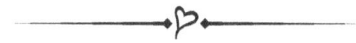

Materials required: Raw wax, Clay soil, Black soil, Bricks, Cow-dung cake, Sand, Ironware, Iron tools, Iron brush, Bell metal

Prerequisite Knowledge:
1. Skill of making model
2. Use of Blast furnace

<u>Step 1</u>: Make the desired model with bee-wax

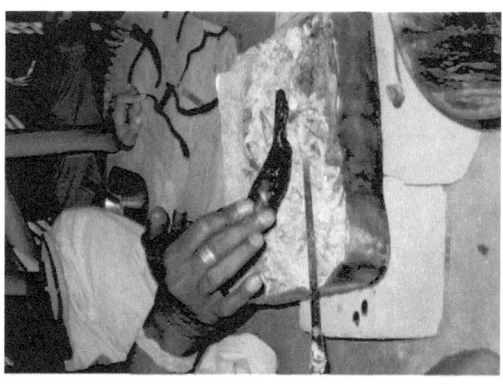

Step 2: Cover the solid model (model of step 1) with the mixture of clay soil and cow-dung and keep a hole at the top and at one side.

Step 3: Again cover the model with black soil keeping the hole opened and dry it in sunlight.

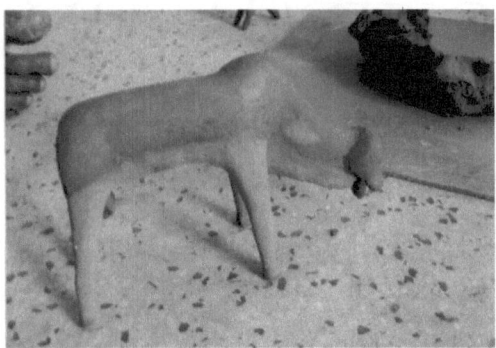

Step 4: Now connect a channel with the hole and keep the solid bell-metal in the channel covering it on the top.

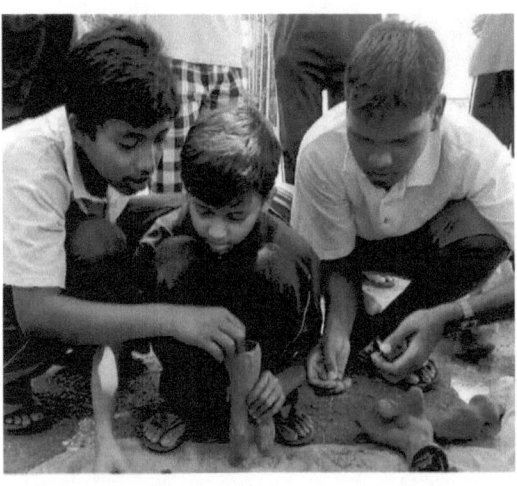

Step 5:Keep the model in the blast furnace horizontally; we kept a hole in the side of the model, so that after burning, the gases produced by burning of wax can blow out.

Step 6:After the burning process is the same as the hollow casting, rotate the model 180° up so that liquid bell metal can enter every space hollowed by the wax.

Step 7:Cool it with water.

Step 8:break down the soil covering so that the desired model could be taken out.

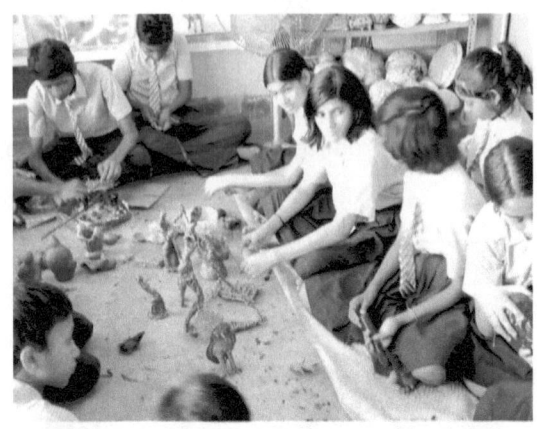

Step 9: Polish the model so that it acquires the desired colour and glaze. Now the model is ready to display.

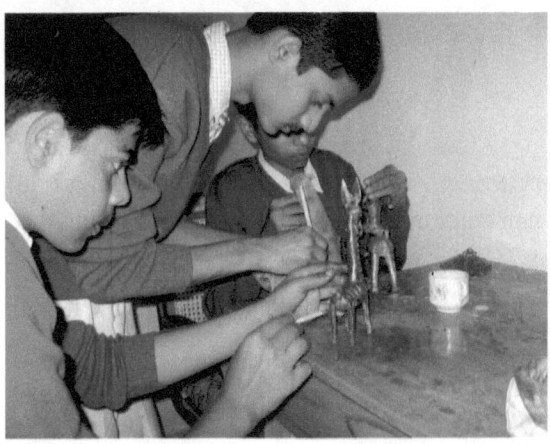

EIGHT
THE AGE OF UNCERTINTY

India is a very diverse country in terms of culture. Almost each state has their own, but unique culture and tradition. Each culture defines their identity and their origin. Though Dokra has a very prosperous potential, it has come to the edge of our tradition. In this modern world, the future of this ancient art is not clear. There are several causes behind this.

The Dokra artists are not sufficiently educated to manage marketing and production. For this the third-party or the middleman arises who buy the products at cheaper costs from the artisans and sell them in the market at higher prices. The producers are not getting the proper wages for their hard work.

Most of the artisans continue their traditional design of work; they are not willing to change their design. But the modern customers want new models does many of these artisans are losing their market.

Though there are many drawbacks of this ancient art, there are also some possibilities for the future of this

traditional art.

Industry: dokra has the potential to create new industries. With modern technology and skilled laborers this industry can boost the economy.

Employment: 6.9% (February 2021) of the total population is unemployed in India. Dokra industry can empower the employment

Preservation of the culture: through the modernization of this art, the culture can be preserved as well as reestablished.

To modernize this traditional art, we need to take some necessary precautions.

Proper education to the marginal communities of dokra additions; they need to be taught the modern techniques which can make their work easy. They need to understand that with the collaboration of modernity, technology and art can coexist.

Proper awareness: awareness about this art should be spread positively to the modern society so that distant people could know about it.

Compulsory education: dokra is one of the heritage cultures of India. This topic should be the textbook so that maximum awareness could be spread.

Financial support: they must be supported financially so that they could work freely.

Awareness among the artisans about the demand of customers: in the old days the dokra art used to produce religious deities and animal figures. But nowadays in this modern society, people are very less interested in religious forms and culture. The modern customers I want some new and unique designs like room decorations, ornaments etc. But most of the artisans are not ready to try new designs, they think the design and forms they inherited from their

ancestors are the best forms.

Despite the poor condition, many people have come forward to revive this ancient art.

Many workshops are being conducted in different places to train the new artisans and to spread awareness among the common people.

Many auctions are being conducted.

Many interested people are helping the poor artists financially.

These initiatives have shown some light for the future of this art. The artisans are getting hope for their better future. The only thing is needed, is the cooperation of the common people.

NINE

DOKRA; A MARK OF ART EDUCATION

Dokra is not just an art but also a technique involving various principles of science, thoughts and ideas which we have inherited. Now -a -days it is emerging as a very popular art form which is based on conservation of our culture. Dokra technique has come from the community of 'Dhokra Damar' which evolved about 4,000 years ago.

In the past era, the community was nomads .Slowly they spread south Kerala, North-West of Rajasthan, East of West Bengal, Jharkhand, Bastar of Chhattisgarh and that's why it is found all over India presently. It is a totally traditional metal casting art work and is also known as Dhokra Metal casting.

Our main theme is to gain knowledge of making idols using this technique. Through this work we can know about the aptitude of the ancient people. As this work needs temperature more than 1000 degree centigrade to melt the brass, it is very much difficult to device this type of

environment without use of modern technology. But amazingly they had achieved this and made the work possible.

Through this technique, we can learn many of the techniques and approximations used in science. How much quantity we have to use to make a particular idol, how much time it will take for the brass to melt, how should be the environment. Any mistake in any of the above may spoil the whole work. Dokra work can be done using two techniques-hollow casting and solid casting. Solid casting produces arts work having only a metal body while hollow casting is applied on a soil body.

Archaeologists' are also interested in Dokra which was found during the research on Indus Valley Civilization, Mohenjo-Daro. Works like terracotta can be considered contemporary to the work and has been a sound source of attention seeking technique. But now a days it is not that much popular. While doing the works on Dokra, we discuss its aspects and thus it becomes a part of learning .Many people are working on it to make it more useful for the Society.

After years of teaching and learning I can say that Dokra casting techniques and processes are very much fascinating because the whole process is very interesting and enthusiastic and with a very pleasant outcome. It develops very good team work; interpersonal relations easily with long lasting effect.

We can learn a lot from the rich history of Indian art. Examples are Ajanta, Ellora Cave, Vimbatka, Sanchi Stupa, Elephanta Cave, Nalanda, Khajuraho etc. In India, the ancient art of painting and Dokra art flourished but today the spread and use of Dokra art has come to a standstill. Some families are still dependent on this dokra art for

generations. The value and spread of this industry has decreased day by day due to the evolution of society. As a result, it takes a lot of labour in this industry. In other words, the work is completed only if the casting is good. If there is any defect in the casting, if the casting is not correct, the art is no longer valuable. Artists of this community live in different parts of our country, Dumka, Bankura, Medinipur. They are working according to the family tradition. But it would not be wrong to say that this industry is sick now.

As an artist I have felt that all artists have a weakness on Dokra Art. I have had a penchant for it since I was a student of the Art College. Next time I will try to find out about the interest in this industry. Who doesn't know about the famous artist Mira Mukherjee? We all know her contribution to Dokra art. She was very helpful to the dokra artists. She used to come Bikna, Dariapur from far away Kolkata by car. She used to help every Dokra artists family with some money. Many older artists know this. Other artists have come to Bikna to help the artists. No one can understand this work except the artists. So from time to time many artists have collaborated with dokra artists to push the art so that this art does not end.

Relevance I started my dokra art from JNV Raigarh, Chhattisgarh then Baghels are spreading Dokra work all around the Chhattisgarh and are getting respect for Dokra work in different places

People's interest in the industry is growing. So I did not stop and the beginning is still going on. But when I came to JNV West Medinipur and started JNV School, I saw the enthusiasm among the students. I increased the enthusiasm towards Dokra in a new way, small workshops. We passed it very well.

After that I got respect for the work. News of my small workshops spread from school to Patna Navodaya regional office. All the officers got praise for their work. The principal was called to the conference as a memento of the guests

Let Dokra art be encouraged more. In West Bengal first we worked in JNV West Medinipur in 2009. Since then in different schools, such as JNV Rajgir, JNV Bokaro, NCERT New Delhi, Some state schools of West Bengal.

I was invited by NCERT to display the technique in a special training and co-ordinate the program successfully. In the program the technique was explained and displayed to various teachers from different parts of India. This was very fruitful and productive for the conservation and recognition of it.

I was able to do the best job in my dokra footsteps, in NCERT New Delhi and Rajgir. In NCERT, everyone was a skilled teacher. They came from different provinces and learned to work well. They promised to do as much as they can. And on the last day everyone honoured us with joy. This twelve day long workshop was the best work of their life as they reported.

Again, if I see Rajgir's story, we have casted it in front of the Collector and have been honoured. But the only thing is how the industry can be saved from the sick condition and can be further promoted. Lost wax

Process is the Indian ancient tradition manual method. These dokra artists have been working in this way for a long time. This book is for spreading the message to everyone for preserving this ancient traditional art.

Baghels: A group of people masters in Dokra metal casting.

TEN

THROUGH THE EYES OF THE STUDENTS

The antique looking handcrafted objects of Dhokra with their golden finish are amongst the popular crafts available today. The rustic look of Dhokra makes them extremely striking and appealing. Dhokra Craft uses the traditional method of lost wax process of metal casting, which goes back 4000 years. The same technique has been found in objects from the Harappan Age as well. The name Dhokra is coined after the tribe of Dhokra Damar, who are settled in the central part of India (the regions of Jharkhand, West Bengal, Bihar Orissa and Chhattisgarh). The Bastar region of Chhattisgarh is the most important centre of Dhokra Craft.

We at JNV, Paschim Medinipur held one successful Dhokra Casting workshop in the year of 2009 to experience and glorify our heritage, our ancient tradition. The workshop was done under the guidance of Mr. Somnath Biswas and some enthusiastic students who were ready to put in all their efforts to make it a success. There were several challenges we faced and defended against to come up with the final Dhokra products. From collecting all the raw materials for the casting process, creating furnaces by ourselves, designing and hand-making the sculptures and many more innumerable things we collectively achieved at that stage of our life (we were barely of age 15 to 17 at that time).

At the end of the workshop, we had prepared enough number of Dhokra Casting products to feel proud about the efforts and time that we have put in. We were incarnated inside those ataractic sculptures which our own hands had prepared.

The ancient science combined with tribal simplicity, skill and creativity of the craftsmen results in these

amazing creations. Unfortunately, the extremely time-consuming procedure, expensive raw material and limited craftsmen have caused a steep decline in the availability of Dhokra products. Being in this situation, we were able to achieve the limit that we did was itself the most rewarding thing for us.

From those days to now, I feel proud that no one can take away those moments from us. We were together, building something that is nearly extinct nowadays and we were successful.

<p style="text-align:right">Sourav Kundu
Ex Student
JNV West Medinipur</p>

"A nation's culture resides in the hearts and in the soul of its people..." ---- Mahatma Gandhi

Our loving motherland India is the hub of varieties of colourful Cultures, Languages, Musics, Arts.....etc. But in the era of high modernization, several traditional art forms are

getting oblivion; no doubt Dokra casting is one of them.

Since my childhood I had a passion for art. I used to take drawing classes too, but I barely had any idea about the diversity of art forms. Although the school's art gallery created a vision inside me, seeing those amazing paintings, portraits, sculpture, statues, crafts mesmerized my inner soul.

I was about eleven, a student of sixth standard, on an afternoon of scorching summer when our art sir arranged a class in our school garden. We had no idea about that surprise class; suddenly sir introduced us to the world of DOKRA. Dokra is one of the earliest known methods of Non-ferrous metal casting by using elaborate lost wax technique, and has been used for more than 4000 years in India. The name dokra came from Dhokra Damar tribes who were the traditional metal smiths of Bengal, Odissa & Jharkhand. After that amazing explanation sir exhibited some of his wonderful dokra artworks. I became so fascinated seeing those startling Dokra crafts that I was eagerly waiting for an opportunity to learn the devastating art form.

Lucky me! The next day our Dokra casting learning programme started. I was super excited for that afternoon art class. Sitting under the giant banyan tree, gathering all art students, we all started our journey. Yea it's quite like a journey! Preparing a dokra artifact means going through a beautiful long process. Every step had to be performed very carefully and precisely. Sir used to demonstrate the steps and following his instructions we accustomed the whole process. At very first roughly a basic shape of the sculpture (which I wanted to make) was developed by using rice husk, clay, and cow-dung. Then it was covered by fine clay and let it dry. After a few days by heating bee-wax and dhuna

in mustard oil, I got a concentrated mould which was consoled and wax threads were made from it. Those wax threads were then wrapped around the clay sculpture and decorated nicely. Then we covered the wax model in a mixture of clay and placed it in a burner to burn. At the same time metal was also heated then the molten metal was carefully poured into the model structure through the channel made, and left it to cool for a few hours. Next day by breaking the covered outer clay we finally got our ultimate product. Thereafter it was cleaned and polished by nitric acid for providing final touches. And finally it's ready.

I still remember very clearly a cute little tortoise was made by me and my friend for the very first time. Creating something with our own hands gives us loads of happiness and positive vibes. The joy at that moment in our innocent faces and the gentle smile are still really unforgettable. Thanks to our beloved art sir who gave us such an opportunity to learn something new and inspired us at every moment. It's true that "art washes away from the soul the dust of everyday life". Glimpses of those golden days still knock my heart.

But the saddest part is nowadays people don't give value to these kinds of artifacts. Basically DOKRA craft was kept alive by tribals. But unfortunately the craft is slowly disappearing due to lack of appreciation and appropriate worth. Craftsman are working hard to make dokra ornaments, idols, home decorative sculptures etc but they aren't getting the proper price for their hard work, time involved in making and efficiency.

So we must culture these excellent artefacts and make it successful and popular. I believe dokra crafting is still one of the best and very interesting artwork and one of the oldest art form of human civilization.

It's our responsibility to spread the dokra craft across the globe to give it worldwide fame gradually. After all "The earth without art is just ehh!"---- Demetri Martin

<div style="text-align: right;">
Prerana Raut

Ex student

JNV West Medinipur
</div>

ELEVEN
Album

—♡—

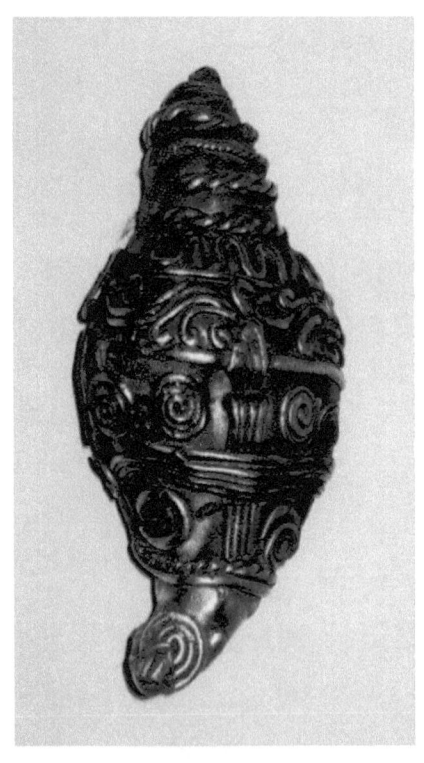

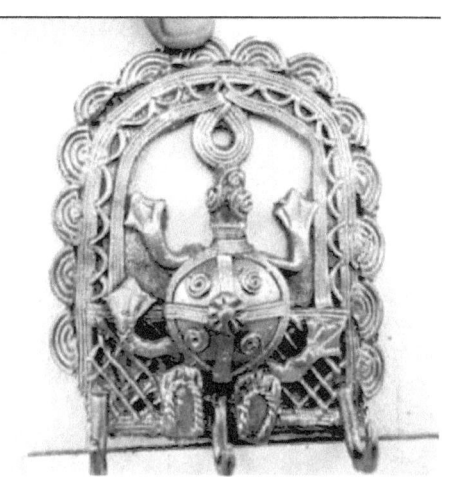

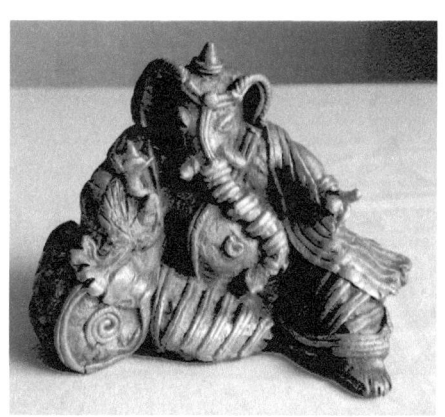

DOKRA

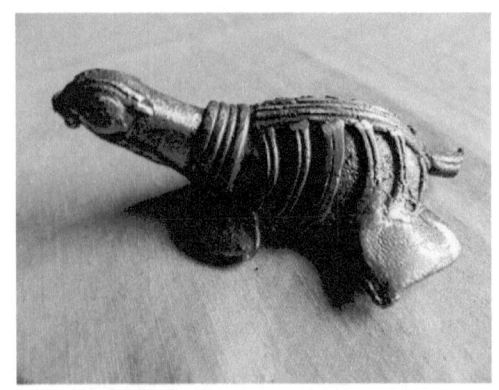

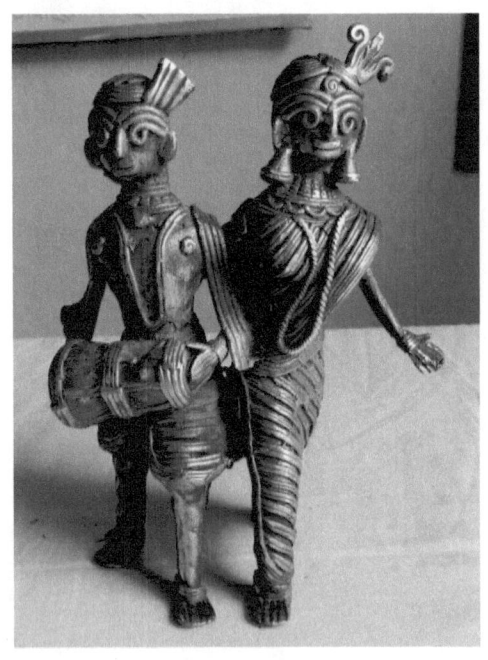

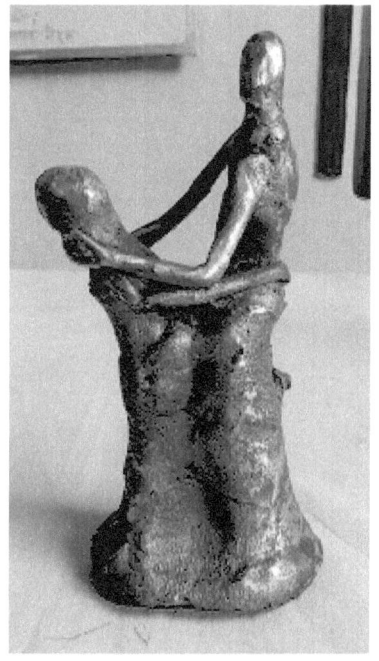

DOKRA

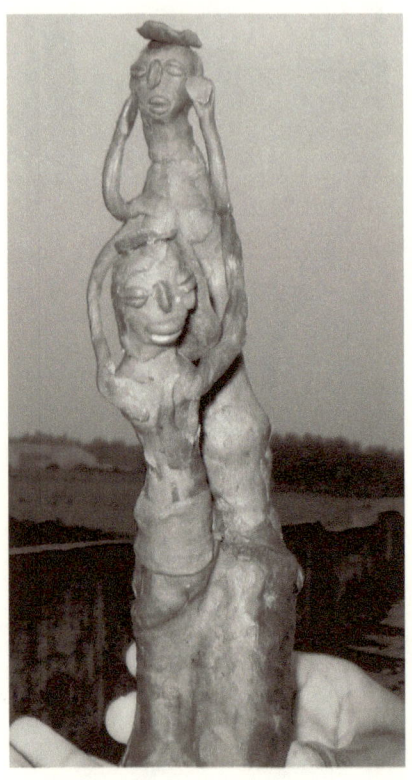

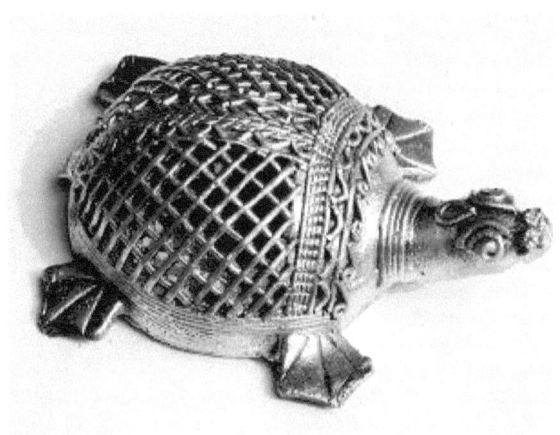

www.ingramcontent.com/pod-product-compliance
Lightning Source LLC
Chambersburg PA
CBHW021042180526
45163CB00005B/2241